T0266861

HALF DOME

YOSEMITE ICON

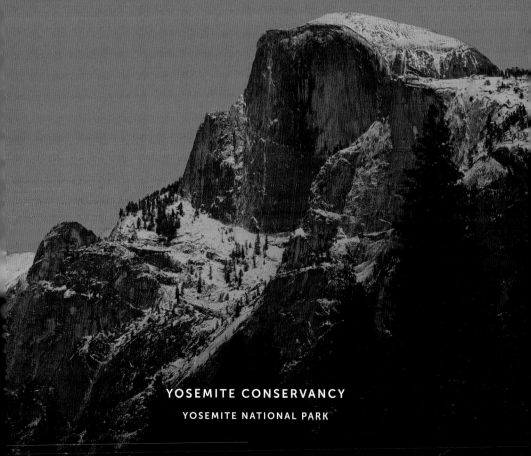

YOSEMITE CONSERVANCY

YOSEMITE NATIONAL PARK

INTRODUCTION

You picked up this book to get to know Half Dome. We'll introduce you to the star attraction soon—but first, take a minute to meet Yosemite National Park.

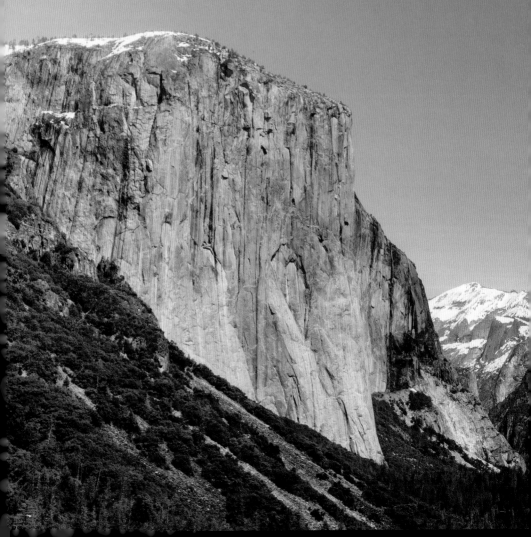

Yosemite covers a 1,187-square-mile (3,074 km²) patch of California near the middle of the Sierra Nevada range and is known for its rock formations, waterfalls, and colossal trees. It's home to more than 750 miles (1,200 km) of trails. The federally designated Yosemite Wilderness accounts for most of the park's area.

Yosemite's mostly uninterrupted terrain and its wide elevation range—from 1,800 feet (549 m) to over 13,000 feet (3,962 m)—supports more than one thousand plant species, four-hundred-plus vertebrate species, and too many insect species to count. Those numbers include well-known species, such as black bears, mule deer, and dogwood, and rare ones that may be new to you. Congdon's woolly sunflowers and Mount Lyell salamanders, for example, live only in the Yosemite area.

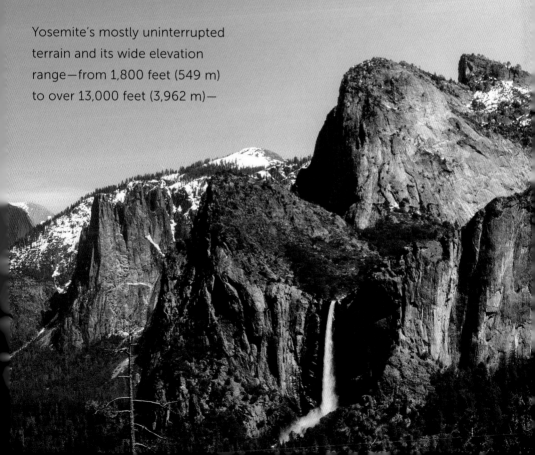

One of the first things you'll notice in Yosemite is the granite. Eons ago, that granite was molten rock, which then solidified far underground and became exposed as overlying rock eroded away and the Sierra uplifted. Over time, it tilted to the west and formed the wedge-shaped Sierra Nevada. Erosion and glaciers sculpted and sanded the Yosemite landscape, leaving polished cliffs and domes, spindly spires, U-shaped valleys, leaping waterfalls, and the occasional erratic boulder dropped by slow-moving ice.

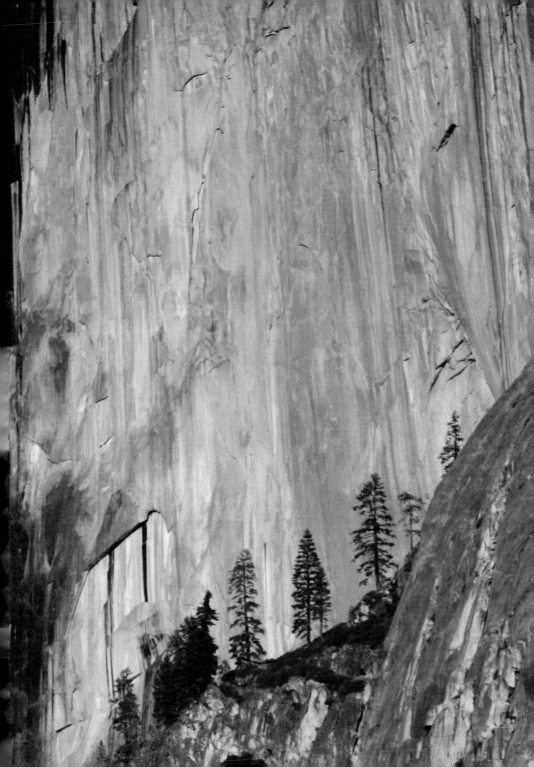

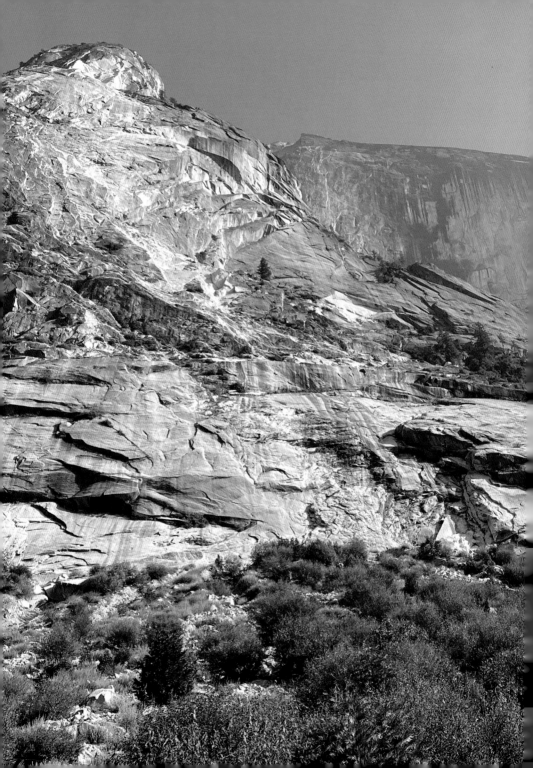

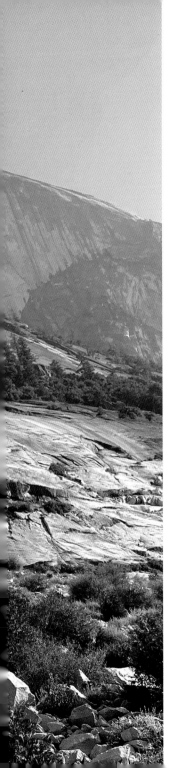

Since time immemorial, Yosemite has been the ancestral home of the people now known as the Bishop Paiute Tribe, Bridgeport Indian Colony, Mono Lake Kutzadika[a] Tribe, North Fork Rancheria of Mono Indians of California, Picayune Rancheria of Chukchansi Indians, Southern Sierra Miwuk Nation, and Tuolumne Band of Me-Wuk Indians. The people retain deep cultural, spiritual, and ecological ties to the land. When exploring Yosemite, please remember that this place is still home to the Traditionally Associated Tribes, who ask that this sacred landscape be treated with the utmost care and respect.

Today, parts of Yosemite are remarkably like what they would have been a hundred or a thousand years ago; others are completely different. The terrain shifts with rockfalls, floods, and erosion, but it largely holds steady. Roads and buildings seem to dominate some sections of the park, but you'll also find forests, lakes, meadows, and other areas where the landscape feels ancient.

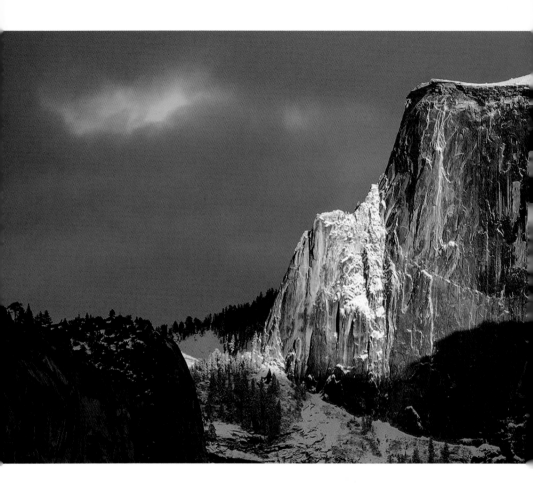

Nothing embodies Yosemite's geologic and human history more clearly than the celebrated natural features known as the icons. They share common traits: instantly identifiable, unique to the park, culturally significant, and enormous.

Half Dome is arguably the most famous Yosemite icon. Rising from the east end of Yosemite Valley, it's impossible to miss. Depending on your interests, you may know it best

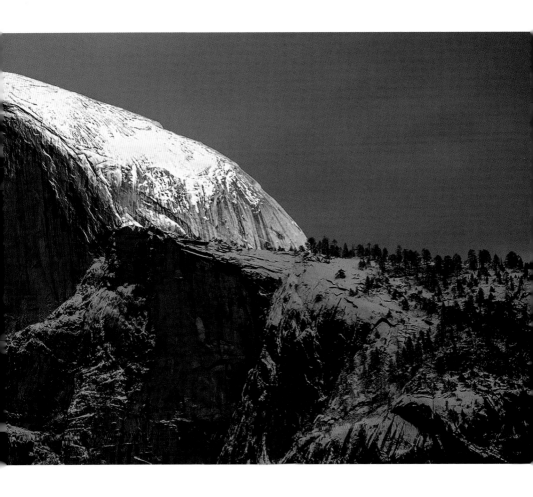

as a geologically fascinating remnant of tectonic processes and glaciation, a hiking bucket-list item, or a camera-friendly subject of selfies and professional shots alike.

If you're new to Half Dome, consider this book the foundation of what is sure to be a long relationship. If you're a Yosemite aficionado, let it rekindle your love for this granite behemoth. Either way, enjoy!

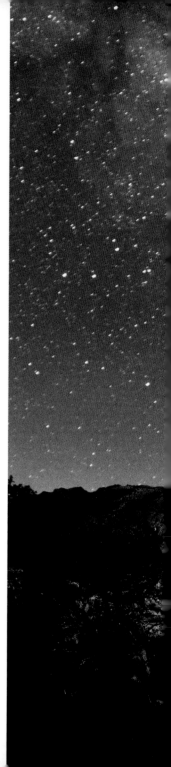

Natural History

Half Dome is easy to spot in Yosemite Valley. Towering over rivers and meadows, it stretches 4,737 feet (1,444 m) from the floor of the Valley to top out at an elevation of 8,844 feet (2,696 m) above sea level.

THE BASICS

You can probably guess the first question most people ask about Half Dome: "What happened to the other half?" Brace yourself: Half Dome is not half a dome. It's closer to 80 percent of a long, sloping fin of rock.

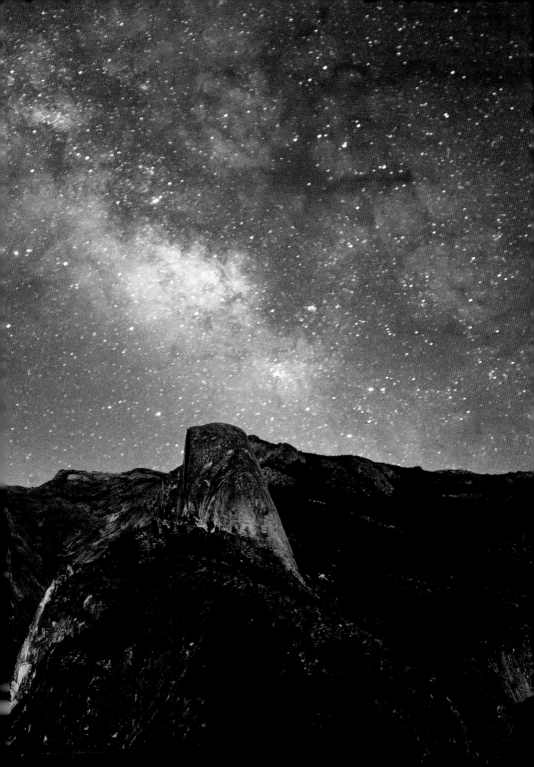

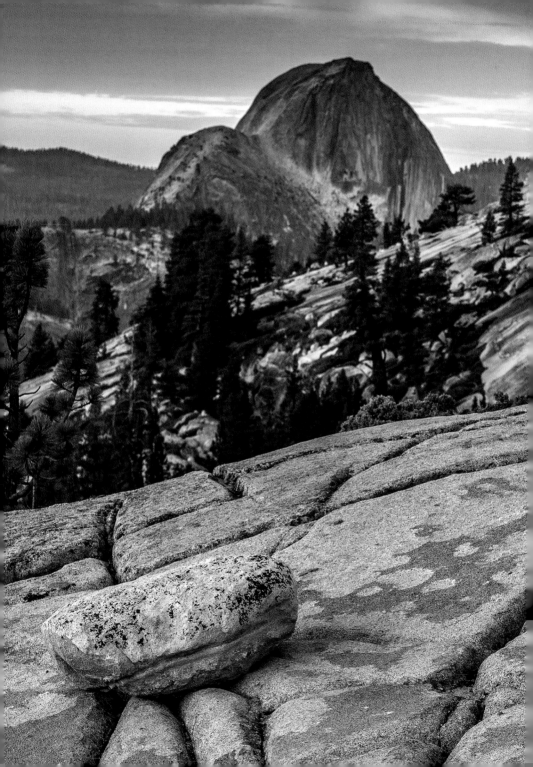

At one point, Half Dome was an indistinct hunk of granite, the cooled remains of crystallized magma. Over time, layers of rock cleaved off, leaving a strikingly steep cliff with rounded shoulders. Glaciers helped, but natural weathering has done most of the sculpting. As overlying rock gave way to erosive elements, newly exposed granite expanded and broke away in sheets.

Half Dome is *still* shape-shifting. Wind and water continue to eat away at the rock. On a human timescale, the pace of change is almost imperceptible, but it is happening. Occasionally slabs break off, sliding down and crashing to the Valley floor.

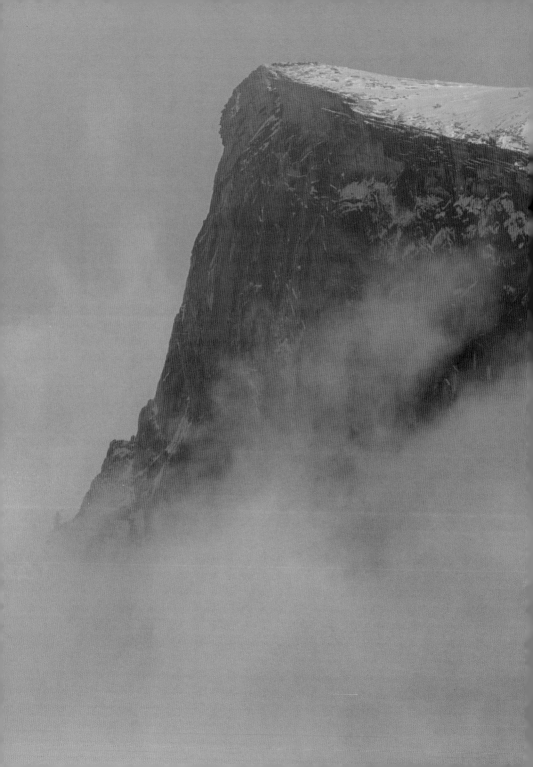

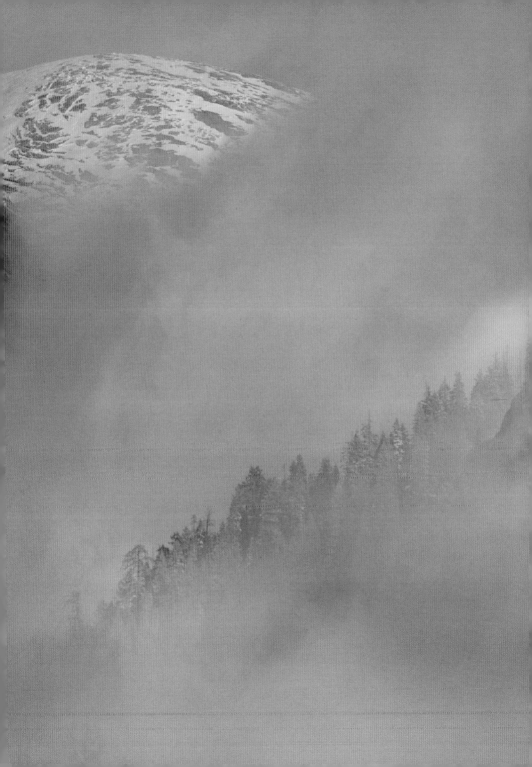

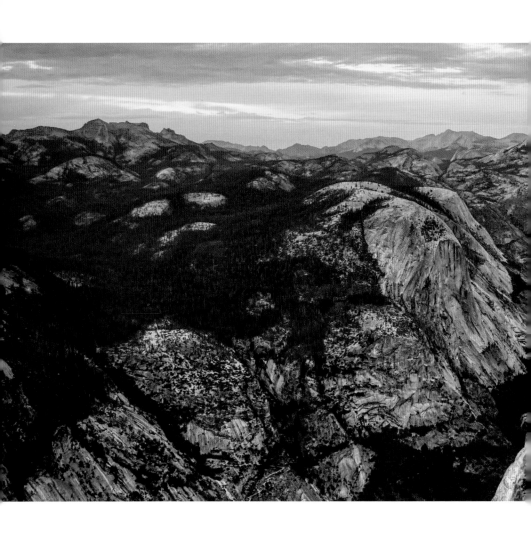

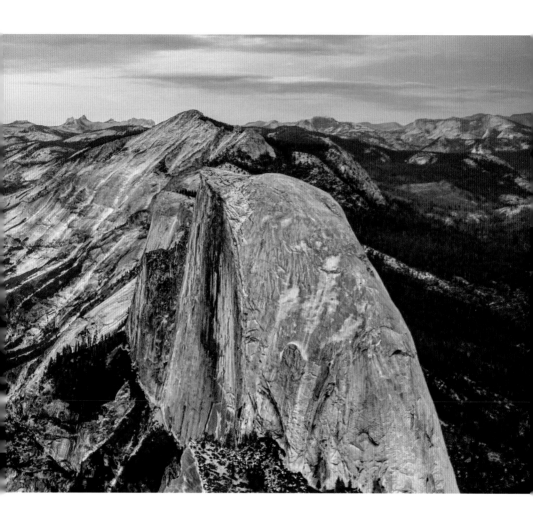

The list could go on and on; after all, Half Dome is part of a massive mountain range replete with pinnacles, cliffs, and ravines. For visual context, head to Glacier Point, where you can not only see Half Dome and its neighbors but also trace the paths of rivers and the long-ago glaciers that helped shape this landscape.

Wasn't Yosemite the first national park? Not quite. When Yosemite was first placed under California's control, in 1864, it became the first state park. Yosemite fans will tell you that Yellowstone only got the "first national park" title on a technicality: When Yellowstone was established, in 1872, Wyoming and Montana weren't yet states, so the new park fell under federal jurisdiction.

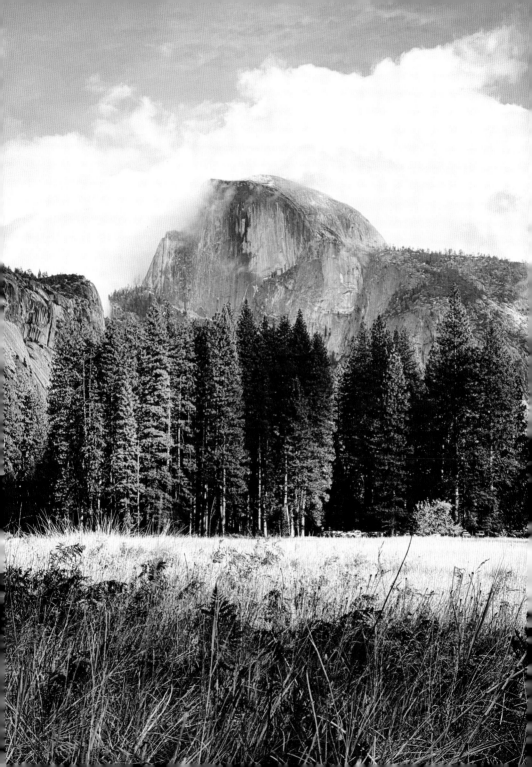

PLANTS AND ANIMALS

I t may be surprising, but this exposed rock which is prone to quick temperature changes and lightning strikes bustles with life. Even the granite seems alive. See the dark brown and black streaks on the face, like drips from a giant paintbrush? That's lichen and moss growing soil-free in channels where water trickles down the rock.

On the trail, you'll find ponderosa pines, known for their puzzle-piece bark. You won't see this pine species climbing Half Dome, but it is climbing in its own way: As a result of climate change, its range has been moving up in elevation. If you're trekking up Half Dome, you may see tenacious trees, such as Jeffrey pines, clinging to the rock in sparse patches, surviving on minimal soil. Low-growing plants, such as granite buckwheat, pinemat manzanita, and mountain jewelflower, persist in rocky crannies.

On the summit, look for sunbathing fence lizards with their telltale blue bellies, and for speedy white-throated swifts sporting black-and-white feathers. Ground squirrels try to snag hikers' trail snacks. Don't let them! How do small mammals get to the top of Half Dome? The same way people do. If you're trekking up Half Dome's steep shoulder, you might spot a yellow-bellied marmot casually scaling the slope beside you.

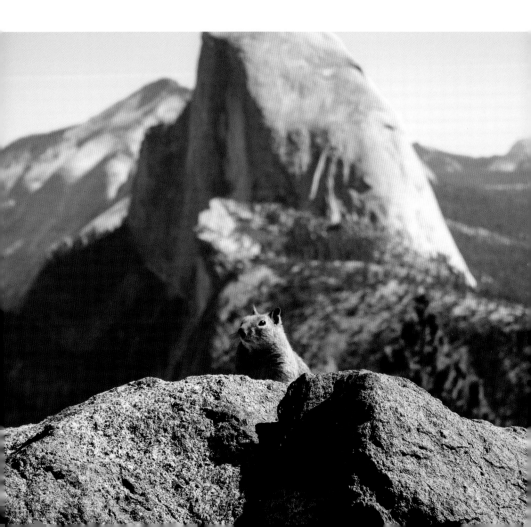

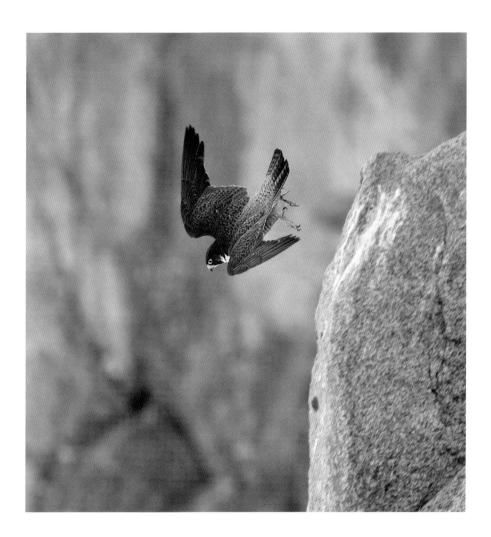

The rocky walls on and around Half Dome are popular with cliff-dwelling creatures, including shiny millipedes and golden eagles. Bats roost in cracks, swooping out at dusk to catch bugs. If you're lucky, you might spot peregrine falcons diving around the cliffs.

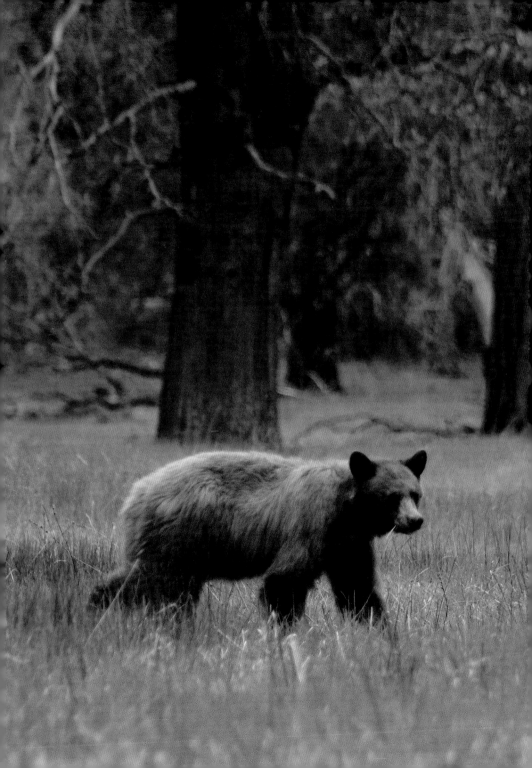

While you can find plenty of plants and animals at Half Dome's high elevations, the meadows and forests below this icon offer even more opportunities to observe Yosemite's impressive biodiversity. In the lower-elevation areas, you may see mule deer and coyotes, California quail, or even a pointy-eared bobcat. Black bears roam Half Dome's base and are especially common in Little Yosemite Valley. They typically emerge from their dens in spring and stay active through late fall, leaving clues such as five-toed tracks, scratched bark, and sizable scat. Help the bears stay wild by keeping your food within arm's reach or in a closed bear canister.

In spring, listen for migratory birds crooning and chattering over the roar of snowmelt surging through the Merced River. All year round, black-crested Steller's jays, great horned owls, and woodpeckers fill out the symphony.

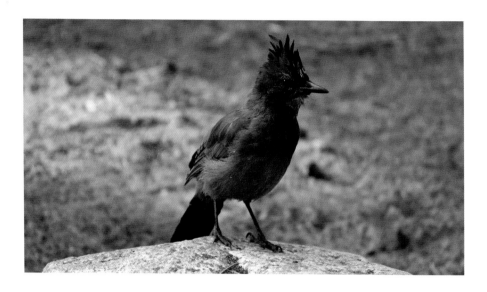

While you're observing and appreciating the plants, animals, and landscape near Half Dome, strive to limit your impact. Keep your food within arm's reach or stored securely. Stay on trails and durable surfaces to protect the delicate ecosystem. That flower may look like it's begging to be tucked into your backpack strap, but it's better off in the soil. Avoid the temptation to stack rocks into cairns—some animals, including the salamanders that dwell on Half Dome's summit, depend on stones for shelter. Capture your surroundings on video, in photos, or in a nature journal, so you can take your experience home without taking pieces of the place with you.

Human History

We've established that
Half Dome is (a) huge,
(b) old, and (c) lively, despite
its barren appearance.
What else draws us in?

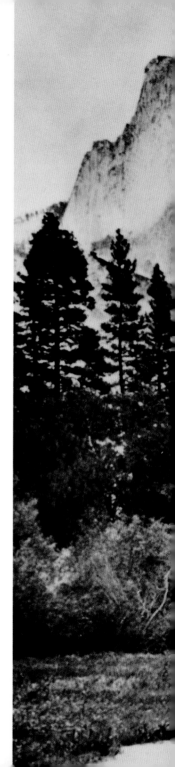

O n Half Dome's geologic timescale,
human history is a blink, yet Half
Dome has earned celebrity status in
part because of its human stories, and
its ability to captivate the imagination.
Paintings, sketches, and photographs
featuring Half Dome helped secure
Yosemite's designation as a national park.

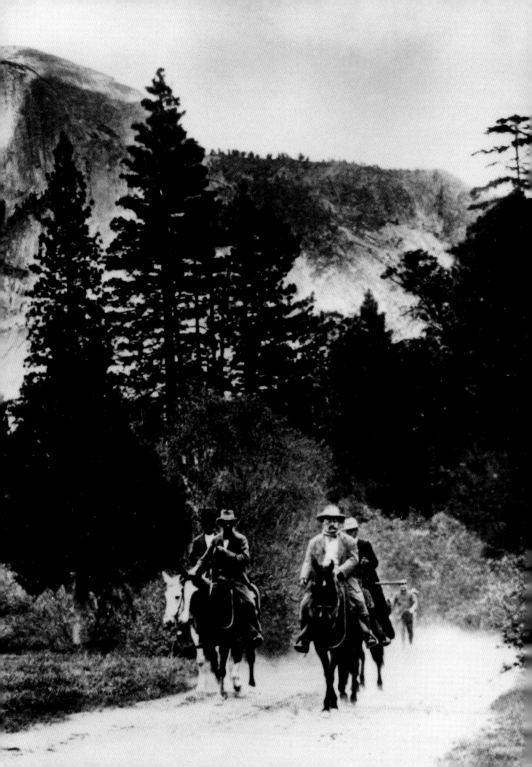

Its grandeur helped propel the careers of celebrated artists, including photographer Ansel Adams and painters Thomas Hill and Chiura Obata. Today, you can spot Half Dome all over: on stamps, on social media, in logos, as computer backdrops. But before any of that, this land was the traditional home of a thriving, diverse community of caretakers who told stories featuring the rock for a long, long time.

AN IDEA BORN OF A HISTORIC WRONG

The people now known as the Traditionally Associated Tribes have long gathered acorns for food and willow to weave baskets. They have tended the land, primarily with fire, to create the meadows we see below Half Dome. Traditional stories about Half Dome have been passed down from generation to generation as a way to forever remember how the great rock was brought into being.

Beginning in 1848 with the California gold rush, miners, herders, and homesteaders seeking treasure and land brought disease and conflict to the people who lived in the Sierra Nevada. In 1851, an armed militia known as the Mariposa Battalion destroyed homes in the Valley, displacing many longtime inhabitants and prefacing the nineteenth-century influx of non-Native business owners and tourists. This was yet another violent chapter in the campaign of state-sponsored genocide that was being waged across California.

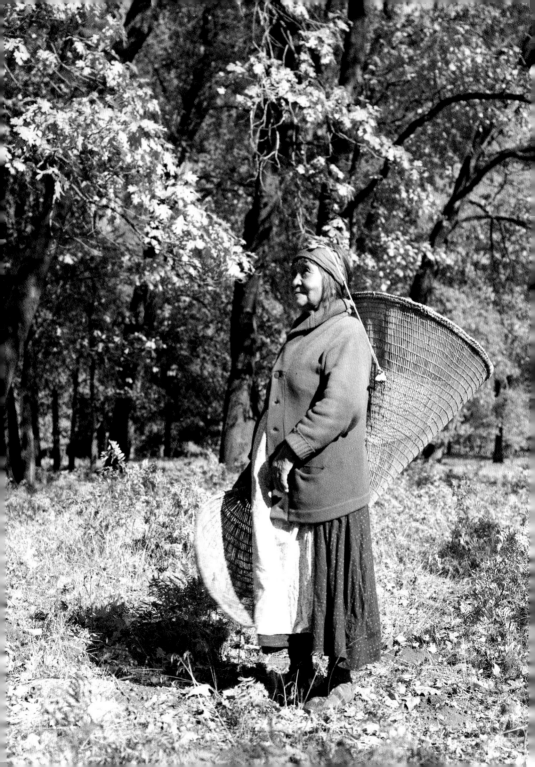

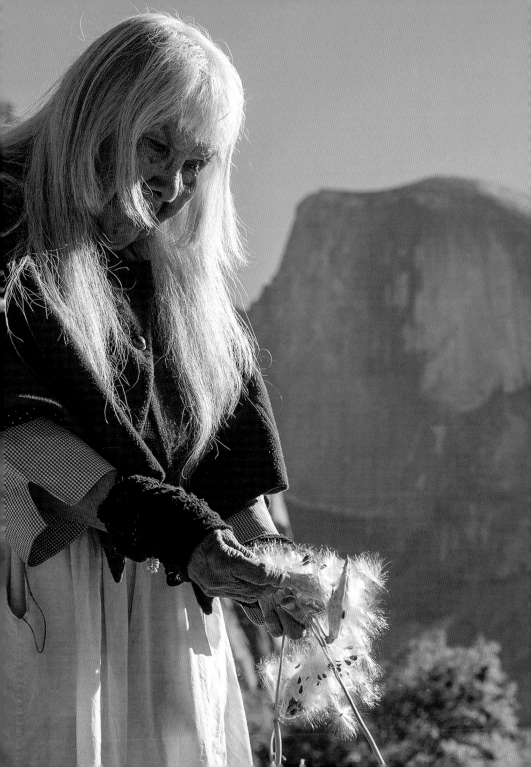

The 1864 Yosemite Grant Act placed Yosemite Valley and the Mariposa Grove of Giant Sequoias under California's purview as the nation's first government-managed land. In 1890, a national park—the country's third—was established to protect land around the Valley and Grove from private development. (These two areas were added to Yosemite National Park in 1906.)

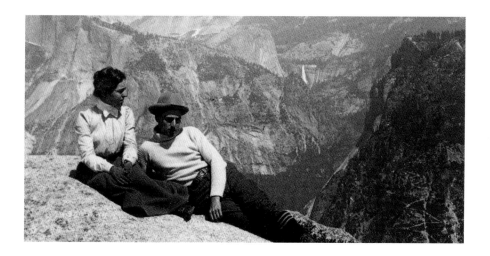

This public-lands legislation ushered in the current era of tourism, construction, and federal management. Some of the people native to Yosemite still lived among the mushrooming non-Native population, often working for the National Park Service (NPS) so they could stay in their ancestral home. The NPS demolished their last village in the Valley in the 1960s. Today, the Traditionally Associated Tribes of Yosemite National Park regularly consult on matters relating to the park and hold events within its borders. For more on their history, practices, and ongoing presence in the Yosemite area, read *Voices of the People* (see Resources, starting on p. 62).

Half Dome has a namesake rock type—Half Dome Granodiorite. It is the youngest plutonic rock in the Valley (but still more than 80 million years old), and you can see it on the cliffs north of The Ahwahnee, west of Royal Arches, near Vernal and Nevada Falls, and, of course, in Half Dome.

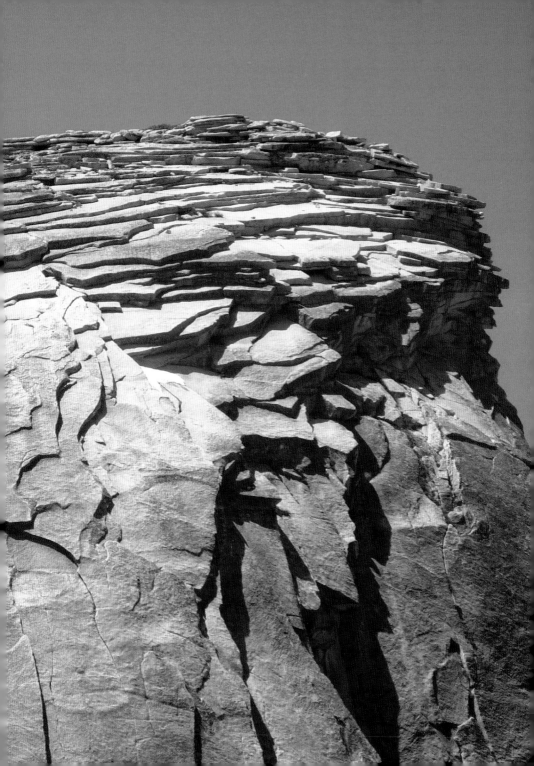

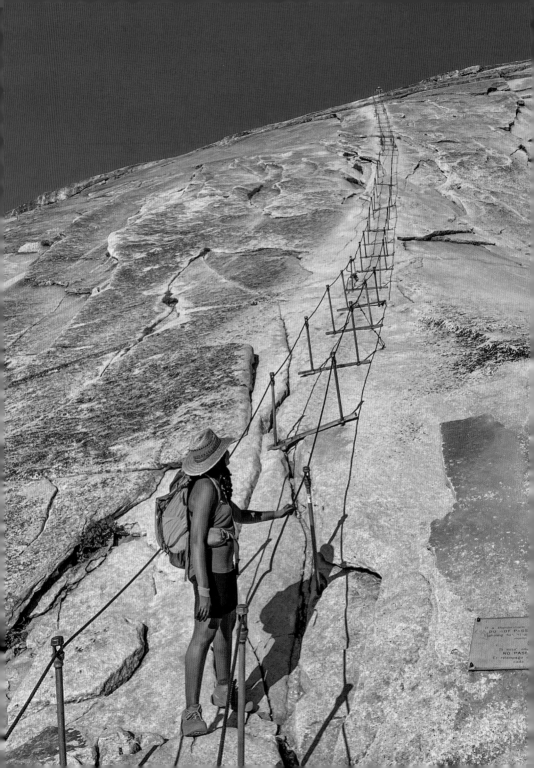

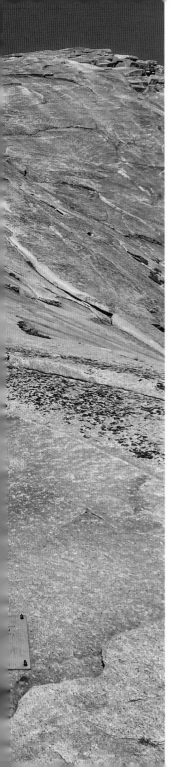

UNCLIMBABLE! OR NOT

H alf Dome's reputation rests not only on its visual appeal but also on its renown as a hiking destination. Yet, in his 1870 *Yosemite Guide-Book*, state geologist Josiah Whitney proclaimed Half Dome "perfectly inaccessible."

We know how that prediction turned out. In October 1875, George Anderson stood on Half Dome's summit, having hauled himself up by rope. After several attempts, including at least once with sticky pine pitch smeared on his feet, he made the first documented ascent, with the help of iron bolts he had drilled into the rock. Later that month, Sarah (Sally) Dutcher, a photographer's assistant in the Valley, became the first recorded woman to reach the top. Other adventurers, including twelve-year-old daredevil Florence Hutchings, soon followed.

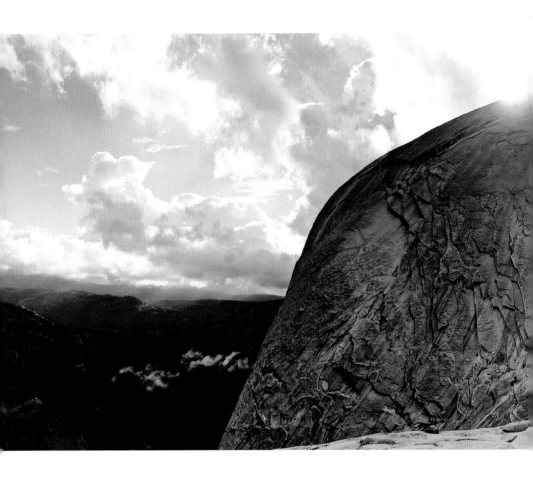

These days, Half Dome–bound hikers pull themselves up a pair of rigid, twisted metal cables that follow Anderson's route on the east side. The first cables were installed by the Sierra Club and the National Park Service in 1919, and they were replaced with thicker steel by the Civilian Conservation Corps in the 1930s. NPS crews take the cables down after the hiking season each fall, then put them back up in the spring.

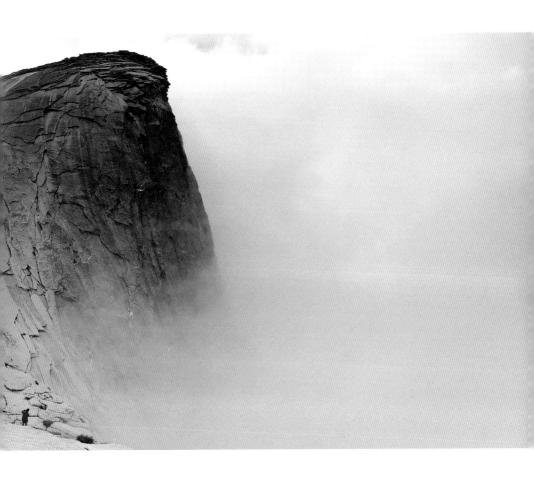

Tens of thousands of people have reached the top of Half Dome. Most go up the cables, but some follow even more technical climbing routes. Royal Robbins, Mike Sherrick, and Jerry Gallwas made the first documented climb of the northwest face in 1957, and a decade later, Robbins's wife, Liz, became the first known woman to scale that route. In 1991, mountaineer Mark Wellman became the first paraplegic climber to ascend the face. For more on the history of Half Dome ascents, stop by the climbing exhibit in Yosemite Village.

SCIENCE, SAFETY, AND STEWARDSHIP

R ecreational climbers and hikers aren't the only people you'll see on and around Half Dome. Keep an eye out for scientists and park rangers, too.

On Half Dome's face, you might spy a park geologist, harnessed up and assessing the rock a few thousand feet above the Valley floor, or it might be a stewardship volunteer collecting abandoned gear and litter. At nearby Vernal Fall, you could run into botanists examining water-loving plants that thrive in waterfall spray, or lichenologists inspecting . . . you guessed it, lichen. In meadows around Half Dome's base, look for surveyors searching for signs of peregrine falcons.

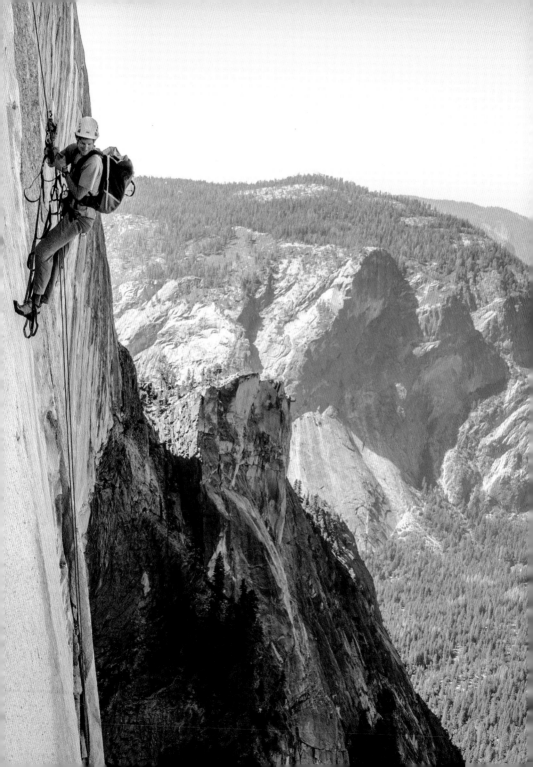

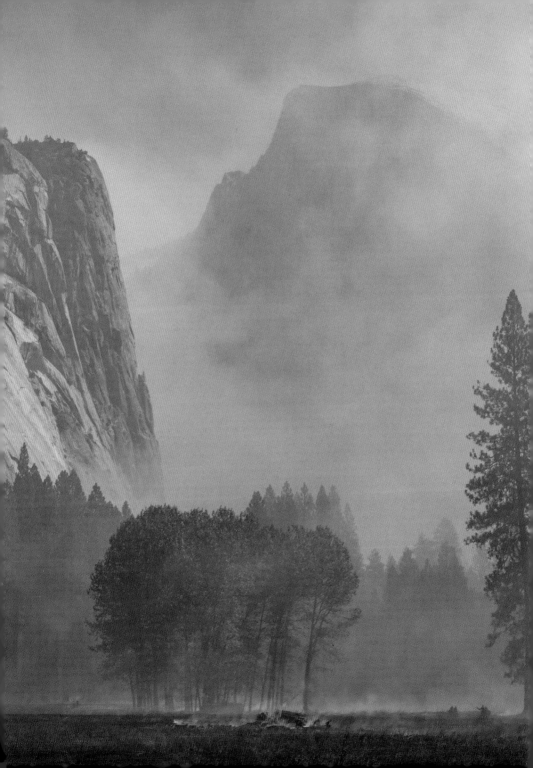

Scientists study Half Dome, and the plants, animals, and processes that make up its ecosystem, to better understand Yosemite's geologic past and natural history, as well as what may be in store. What triggers rockfalls? How well are peregrines rebounding from their near extinction in the 1970s? What can Half Dome's lichen communities tell us about air quality? How will organisms that rely on this icon and its surroundings fare as climate change drives temperatures higher and intensifies storms, wildfires, and droughts?

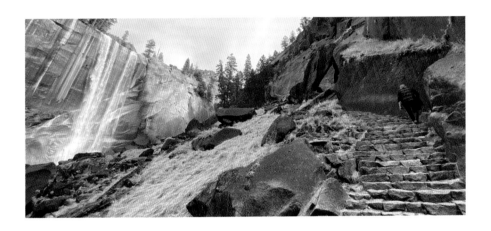

If you're hiking to Half Dome in the summer, you might come across crews working on trail repairs, helping to make your route as hazard-free as possible. Watch also for the preventive search and rescue team, made up of park rangers and volunteers stationed along the Mist Trail to answer questions and offer safety guidance. They'll be ready with perennial advice (plan ahead, stay hydrated, and avoid fast water), and they'll also have the latest information on daily and seasonal conditions.

Visiting Half Dome

Whether you're saying hello to Half Dome for the first or fifteenth time, being in the presence of such an enormous, ancient rock is almost guaranteed to be a memorable experience. Make the most of your time with this granite icon by observing it from different angles, watching it shift with the seasons, or hiking to its base or summit.

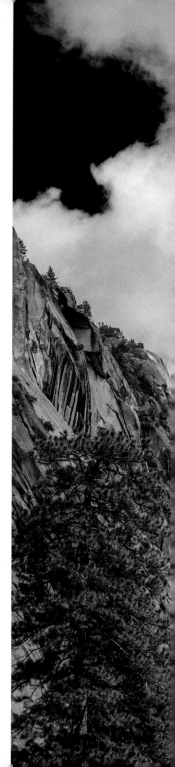

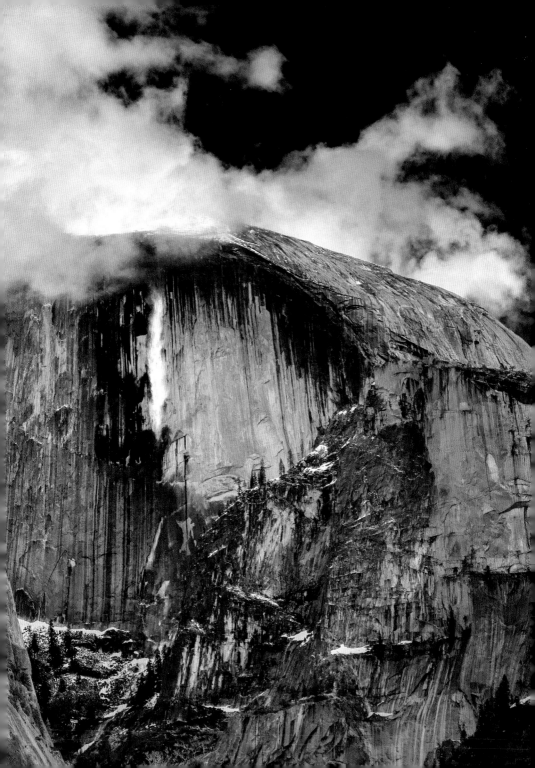

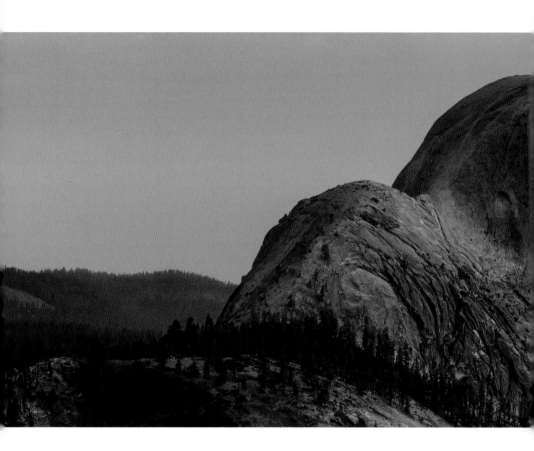

GETTING ORIENTED

S tart off simple: Take in Half Dome's massive scale and distinct shape. You might catch yourself staring at it for minutes on end—especially at dawn, when Half Dome's silhouette takes shape, and at sunset, when the granite picks up a rosy hue called "alpenglow."

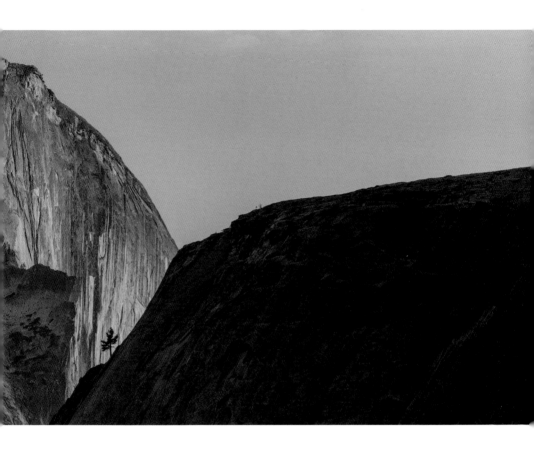

From the floor of Yosemite Valley, you'll be looking at Half Dome's northwest face. The "back"—the part that doesn't have the instantly recognizable flat cliff—is out of view, to the southeast.

Half Dome is so big, and so recognizable, that you can use it to orient yourself from different parts of the park. It's like a neon sign declaring, "Hey, Yosemite Valley is this way!" If you hike up Mount Hoffmann (10,856 feet/3,309 m), near the park's geographic center, you'll get a clear view of Half Dome about 7 miles (11 km) to the south.

Things you may see on your way to Half Dome: piles of bat guano, rainbows in the mist at Vernal Fall, and a heap of gloves discarded by hikers who used them for better grip on the cables. (If you bring gloves or grab a pair from the pile, pack them out.)

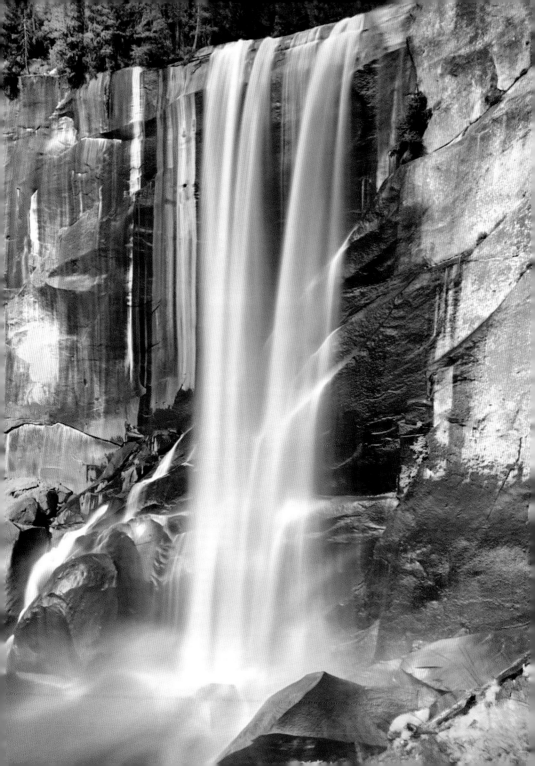

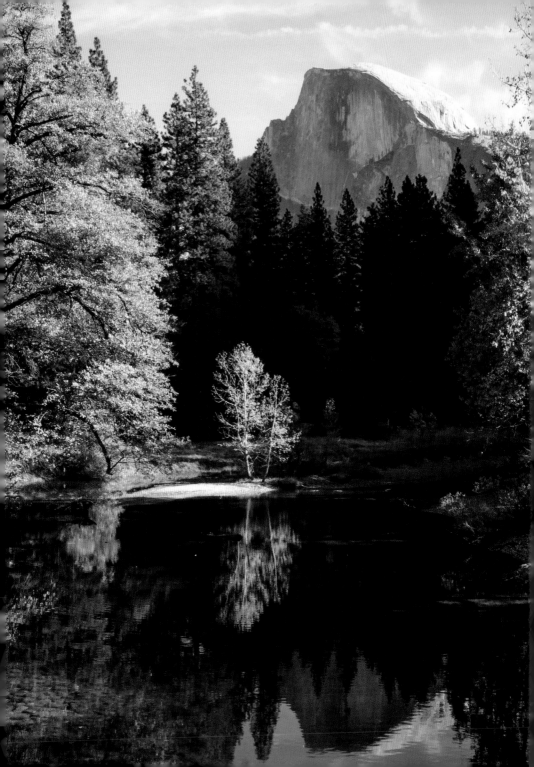

CAPTURING THE VIEW

One look tells you that Half Dome is more photogenic than most big rocks. It's long been a go-to subject for sketching and painting, too. Watch the mood shift as light moves across the granite. In spite of its enormous size, much of its beauty is in the details. Can you see pale scars from rockfalls, or hardy conifers high on the slopes?

For a famous Half Dome vista, stop by Cook's Meadow, which offers a view of the icon's face from a wooden boardwalk. Or head to Sentinel Bridge, where Half Dome looms ahead and is often reflected in the Merced River below. (Two views in one!)

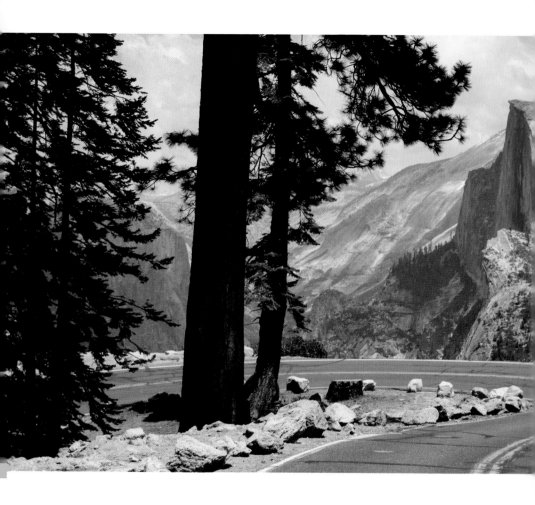

At Tunnel View (on Wawona Road), look for the dome framed by El Capitan, Cathedral Rocks, and Bridalveil Fall. Drive or walk up to the Valley's rim via Glacier Point Road to catch Half Dome alongside high peaks and impressive waterfalls. The views from Glacier Point are spectacular on their own, but a free spotting scope there in summer will give you an extra-close look.

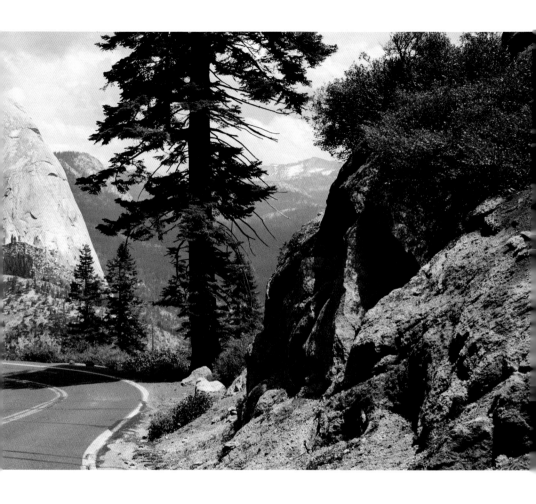

To get a sense of Half Dome's scale, follow the Mirror Lake Trail (a 5-mile/8-km loop), which passes by its base. A short hike up the Yosemite Falls Trail switchbacks to Columbia Rock (1 mile/1.6 km one way, with 1,000 feet/305 m of elevation gain!) leads to open views of Half Dome and neighboring North Dome. You can also get a close look at Half Dome's face from North Dome (4.4 miles/7 km one way from Porcupine Flat) when Tioga Road is open, generally late May or June until November.

Or "see" Half Dome from a different perspective by reading about its creation in the book *Voices of the People* (see Resources, starting on p. 62).

If you're driving on Big Oak Flat Road, pull off at Half Dome View (or Merced Canyon Overlook), a stopping point that steers your gaze to its namesake icon far across the Valley. This stop is also home to one of the park's several bronze topographic models. Trace Half Dome with your fingers to feel its shape and how it fits into the landscape.

You'll find another bronze model of Half Dome at Tioga Road's Olmsted Point. There, you can also use your phone camera, binoculars, or a telescope to zoom in on hikers inching up the dome's east side. If you're thinking, *I want to go where they're going!*, read on.

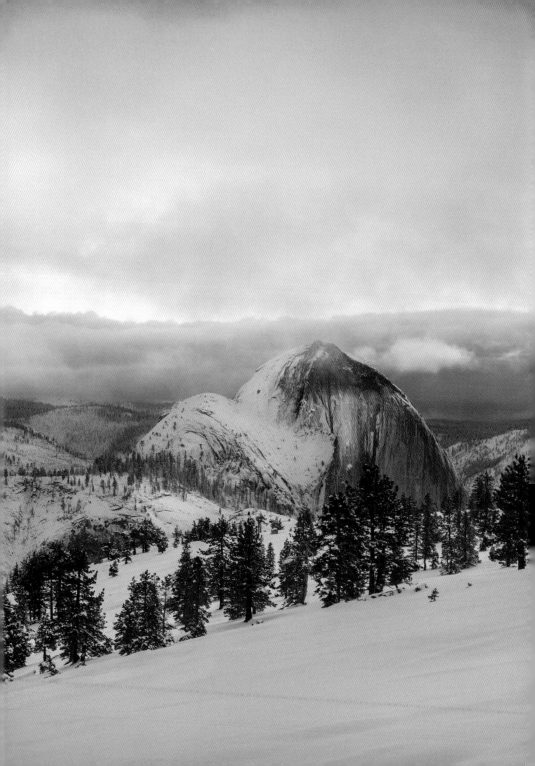

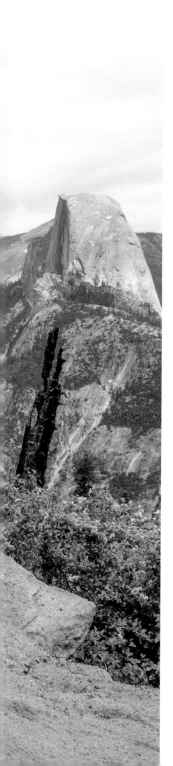

SEEKING THE SUMMIT

You'll need a much-sought-after Half Dome permit to ascend the steel cables that help hikers up the final 425 feet (130 m) to the summit. Yes, it's that steep. The shortest route to and up the cables (via the Mist Trail) is a strenuous 7 miles (11.3 km) one way, and a round-trip trek takes at least 10 hours. Budget extra time to relax on the flat summit, appreciate the panoramic views, and observe inquisitive squirrels.

If you're craving a lofty hike but the cables aren't your thing, consider Clouds Rest (7.3 miles/11.7 km one way from Tioga Road) for equally breathtaking views and a close-up look at your favorite flat-faced, curved-sided formation.

PLANNING YOUR VISIT

The cables are usually in place from late May through early to mid-October, so that's your window for getting to the top. That said, Half Dome is an all-season kind of attraction, and summit-seeking is just one way to experience it.

Half Dome is an epic sight whenever the sun is up, and arguably after dark, too, especially if you can see the Milky Way arcing overhead or can make out climbers' headlamps glowing against the granite. With a coat of winter snow, the rock looks even more majestic than usual: Gaze up at the frosted granite from the Valley, or ski or snowshoe to Glacier and Dewey Points for a glimpse from the south rim.

No matter how you experience Half Dome, count on it to grab your attention and affection. It's hard to spend time in Yosemite without falling in love with this iconic rock.

Yosemite's icons are far more than immense, stunning natural features. They also tell us about the park's past and present, and they prompt questions about its future. How can you help protect this iconic place for future generations?

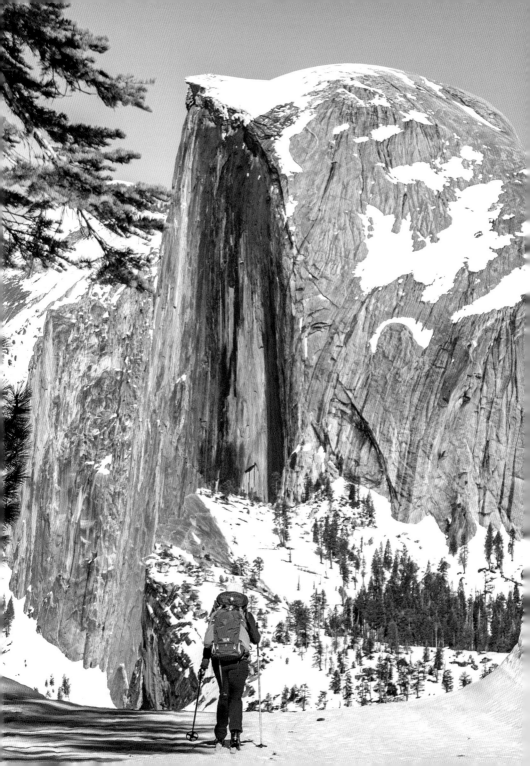

RESOURCES

Check out these resources for more in-depth information on Yosemite and Half Dome, including natural and human history, things to see and do, places to stay, and ways to help protect the park.

Yosemite National Park: The National Park Service manages Yosemite National Park and is your best resource for the most comprehensive and up-to-date information about visiting the park, current conditions, natural resources, history, safety, and more.

WEBSITE: nps.gov/yose. For **trip-planning tips** (including Half Dome–specific guidance and permits), go to nps.gov/yose/planyourvisit.
CALL: 209.372.0200 (general questions). For questions related to trip-planning and permits for the Yosemite Wilderness, including Half Dome, call 209.372.0826 (in service March through September).

Yosemite Conservancy: As Yosemite National Park's cooperating association and philanthropic partner, the Conservancy funds important work in the park and offers a variety of visitor resources and activities, including art classes, guided Outdoor Adventures and Custom Adventures, volunteer programs, and bookstores.

WEBSITE: yosemite.org. To see the Conservancy's four **Yosemite webcams,** including one aimed at Half Dome, visit yosemite.org/webcams.
CALL: 415.434.1782

Yosemite Hospitality: A subsidiary of Aramark, Yosemite Hospitality, LLC, is an official concessioner of Yosemite National Park, and it operates hotels, restaurants, stores, visitor programs, and more.

WEBSITE: travelyosemite.com
CALL: 888.413.8869 (U.S.) or 602.278.8888 (International)

The Ansel Adams Gallery: Located in Yosemite Village, the gallery celebrates Ansel Adams's work and legacy, showcases other photographers who capture the American West, and offers photography workshops.

WEBSITE: anseladams.com **CALL:** 209.372.4413

Voices of the People: This book by the Traditionally Associated Tribes of Yosemite National Park (Bishop Paiute Tribe, Bridgeport Indian Colony, Mono Lake Kutzadika[a] Tribe, North Fork Rancheria of Mono Indians of California, Picayune Rancheria of the Chukchansi Indians, Southern Sierra Miwuk Nation, Tuolumne Band of Me-Wuk Indians) offers detailed information and insights from the people native to the Yosemite area. Published by the National Park Service in 2019, ***Voices of the People*** is available from Yosemite Conservancy and digitally from most e-book vendors.

Yosemite Nature Notes: This series of short documentaries about Yosemite dives into the park's geology, ecology, human stories, and more. For Half Dome–specific content, see Episode 4 ("Half Dome") and Episode 20 ("Granite"). Find all ***Yosemite Nature Notes*** episodes on the Yosemite National Park website (nps.gov/yose/learn/photosmultimedia/ynn.htm).

PHOTO CREDITS

1: Half Dome in winter. Photo by Nick Fedrick.
2, 3: Tunnel View. Photo by Pablo Fierro on Unsplash.
4, 5: Half Dome granodiorite. Photo by Berenice Melis on Unsplash.
6, 7: Half Dome rock fall zone. Photo by Eric Ball.
8, 9: Half Dome evening. Photo by Austin Schmid on Unsplash.
10, 11: Starry night. Photo by Kyle Cottrell on Unsplash.
12, 13: Half Dome, Olmsted Point, sunrise. Photo by Phillip Nicholas Photography.
14, 15: Cotton candy. Photo by Michael Wackerman.
16: Clouds Rest view. Photo by Fred Turner.
18, 19: Half Dome at sunset. Photo by Cameron Venti on Unsplash.
21: Meadow view. Photo by Brian Lovin on Unsplash.
22, 23: Ponderosa pine bark. Photo by Yosemite Conservancy/Adonia Ripple.
24: California ground squirrel. Photo by Julia Solovey.
25: Peregrine falcon. Photo by James McGrew.
26, 27: American black bear. Photo by Caitlin Lee-Roney.
28: A Steller's jay on a rock. Photo by Fred Turner.
29: Wildflowers at North Dome gully. Photo by Sylvia Doyle.
30, 31: Theodore Roosevelt and John Muir arrive in the Valley on horseback. Photo by Southern Pacific Staff; Courtesy of the Yosemite National Park Archives, Museum and Library, RL_18781.
33: Tabuce "Maggie" Howard, cultural demonstrator. Photo by Ralph H. Anderson; Courtesy of the Yosemite National Park Archives, Museum and Library, RL_02159.
34: Julia Parker, basket weaver and cultural demonstrator, gathering plant materials. Photo by Keith Walklet.

35: View from Eagle Peak. Half stereograph by Underwood & Underwood, c. 1902; Library of Congress, ppmsca 18929.

37: Exfoliating granite on Half Dome. Photo courtesy of NPS.

38, 39: Half Dome Cables. Photo by Raukisha Talley.

40, 41: Eastern slope in fog. Photo by Juan Arreguin on Unsplash.

42, 43: Park geologist Greg Stock on a climbing patrol of the Regular Northwest Face of Half Dome. Photo by NPS/Eric Bissell.

44: Awhahnee Meadow Burn. Photo by Paul Moreaux/PMXPhotography.com.

45: The Mist Trail. Photo by Eric Ball.

46, 47: Avalanche on Half Dome. Photo by Phillip Nicholas Photography.

48, 49: Mount Watkins and Half Dome from Olmsted Point. Photo by Michael Wackerman.

50: Vernal Fall rainbow. Photo by Pradyumna Adiraju.

52, 53: Half Dome reflection. Photo by David Grimes.

54, 55: Glacier Point Road. Photo by Josh Carter on Unsplash.

56, 57: Half Dome sunset haze. Photo by Phillip Nicholas Photography.

58, 59: Hiker on the Panorama Trail. Photo by Josh Helling.

60: Half Dome skiing. Photo by Dakota Snider.

Back cover: Half Dome and Clouds Rest sunset. Photo by Madhu Shesharam on Unsplash.

Text copyright © 2022 by Yosemite Conservancy
Photography credits can be found on pages 63–64.

Published in the United States by Yosemite Conservancy.

YOSEMITE
CONSERVANCY.

yosemite.org

Yosemite Conservancy inspires people to support projects and programs that preserve Yosemite and enrich the visitor experience.

Text by Gretchen Roecker
Book design by Eric Ball Design
Cover art by Shawn Ball

ISBN 978-1-951179-19-9

Printed in China by Reliance Printing

1 2 3 4 5 6 – 26 25 24 23 22

FSC
www.fsc.org

MIX
Paper from
responsible sources
FSC® C102842